on Each Other!

Written by Kavita G. Sahai

Illustrated b

D1404223

For more information on Indian cultural activities with kids, please visit www.maharanimamas.com

Inspired by my little Hati's

Pratham USA
Every child in School and Learning Well

Namaste, my name is

Ram.

I am four

and never a bore.

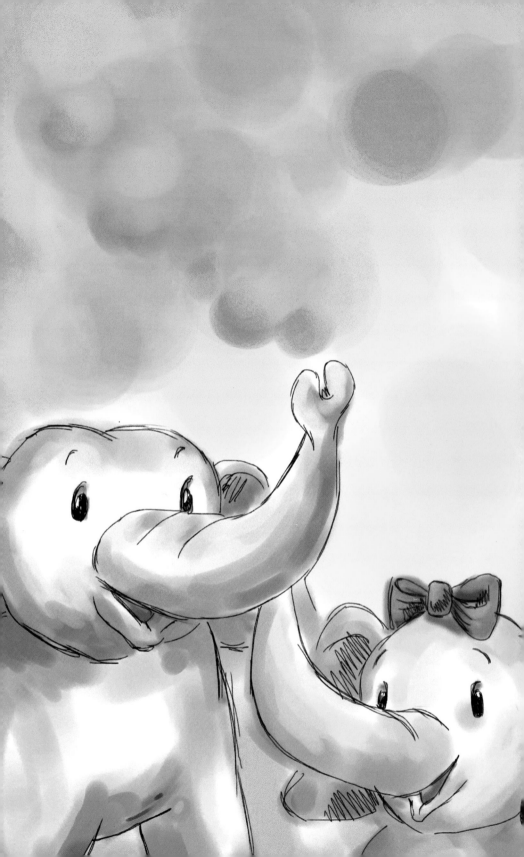

This is my sister Sia
she is almost three
and wants to be like me.

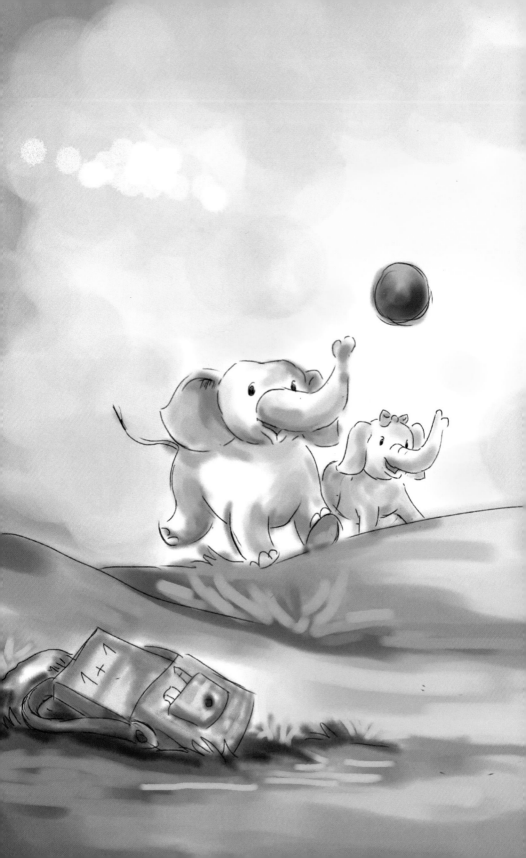

We go to school
because it is cool
when we are done
we get to have fun.

This week is Holi, so
we throw color
on each other.

Holi comes in March after
the full moon
We tried with all our might
and saw the round moon
last night.

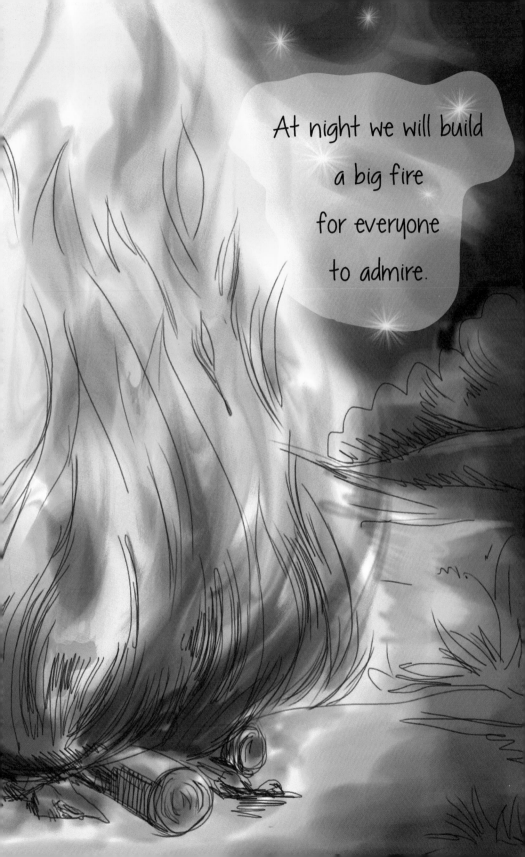

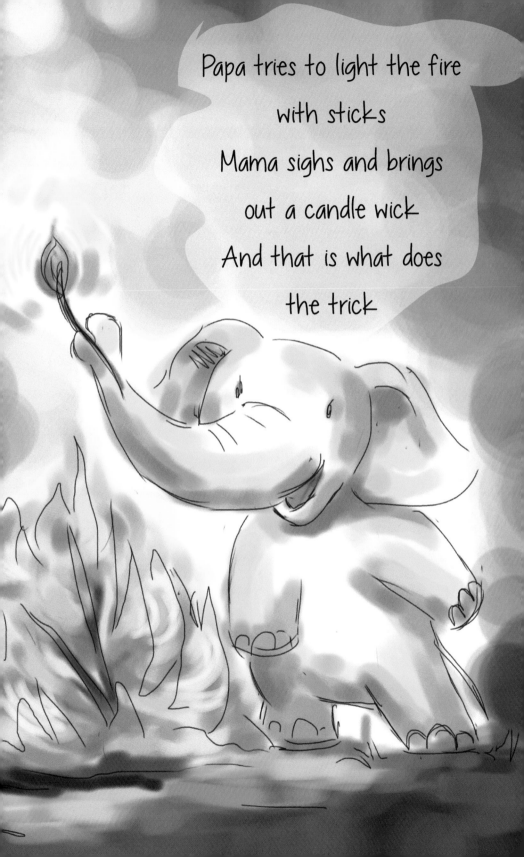

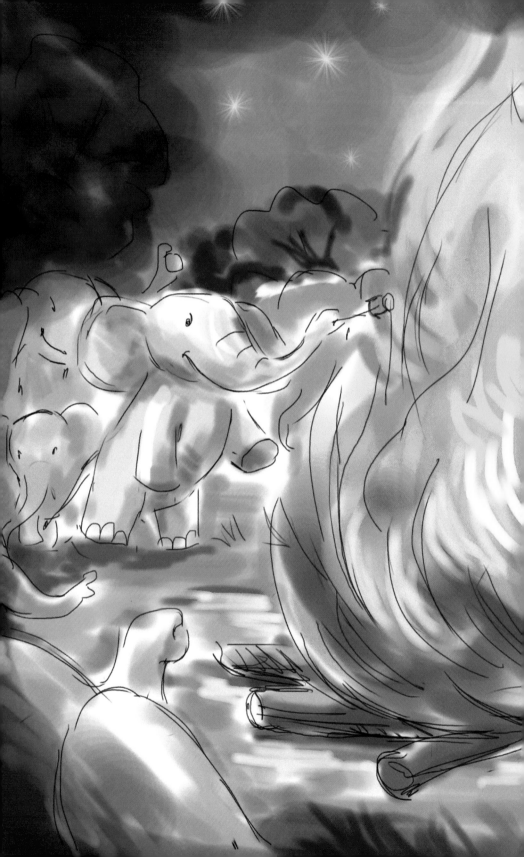

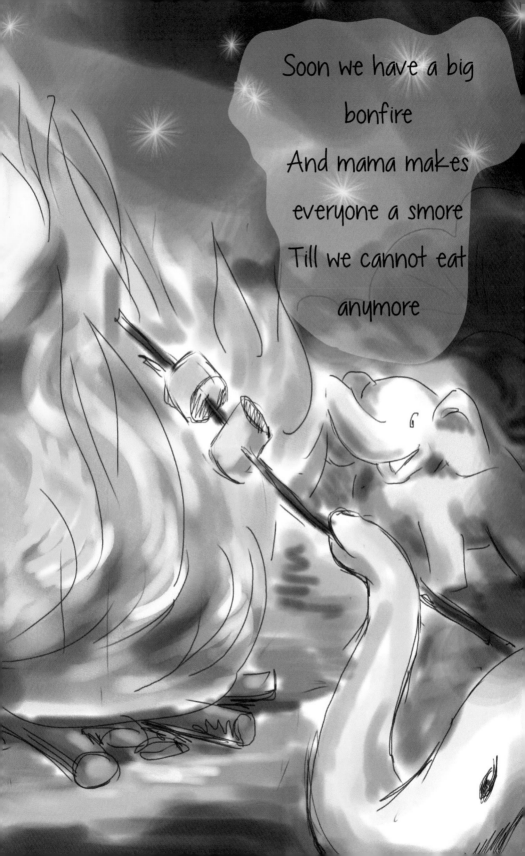

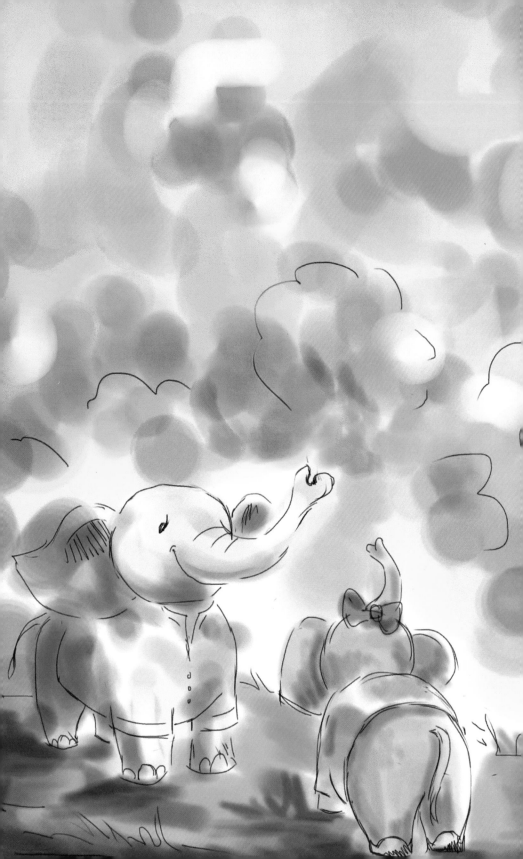

The next day we wear white
and make sure our clothes aren't tight.
It is a sure bet
that we will get wet

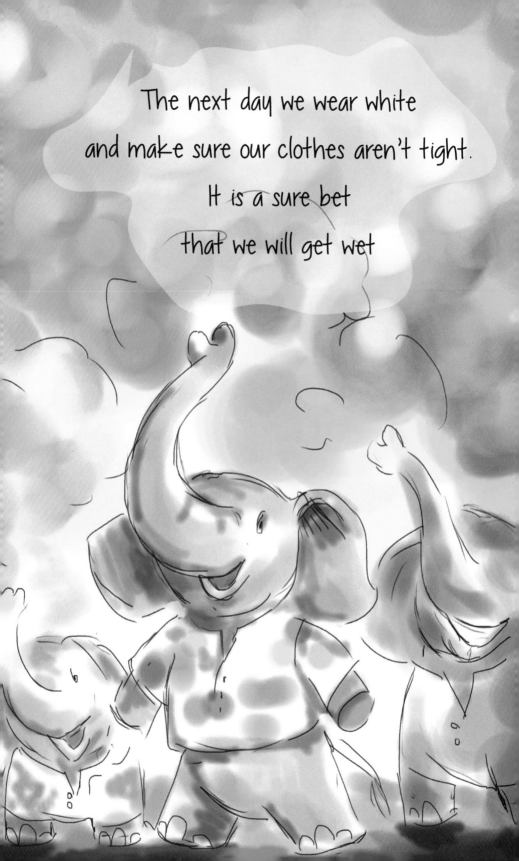

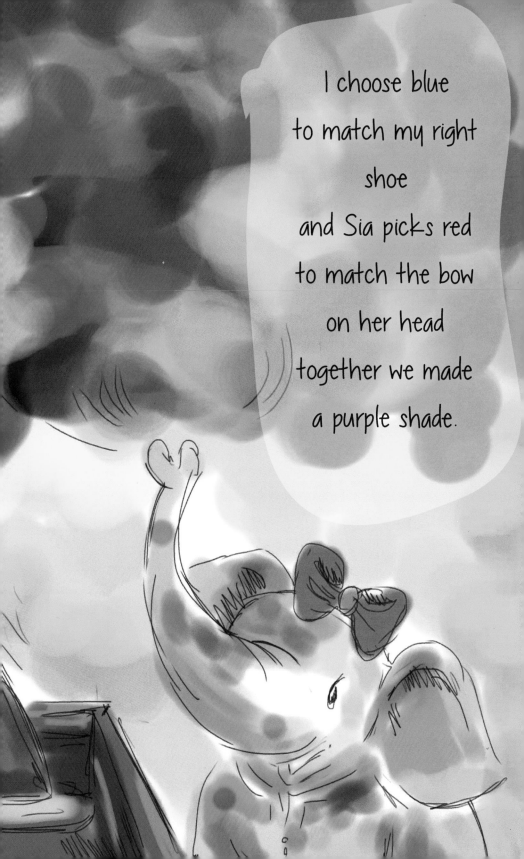

I choose blue
to match my right
shoe
and Sia picks red
to match the bow
on her head
together we made
a purple shade.

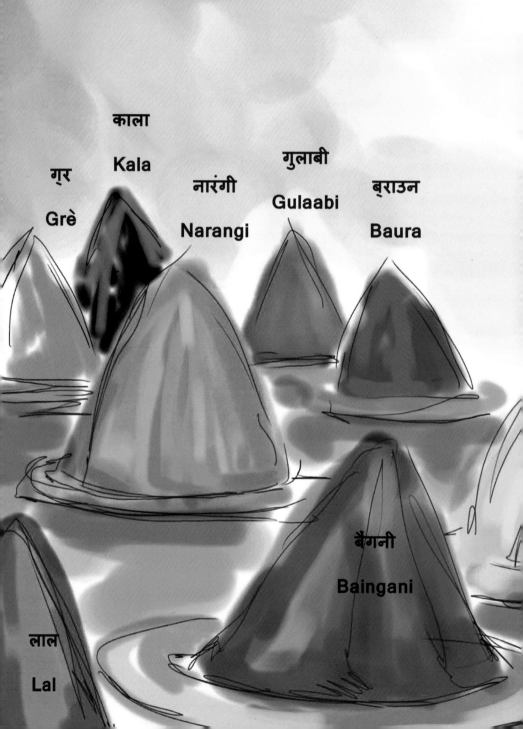

Do you have a favorite color?

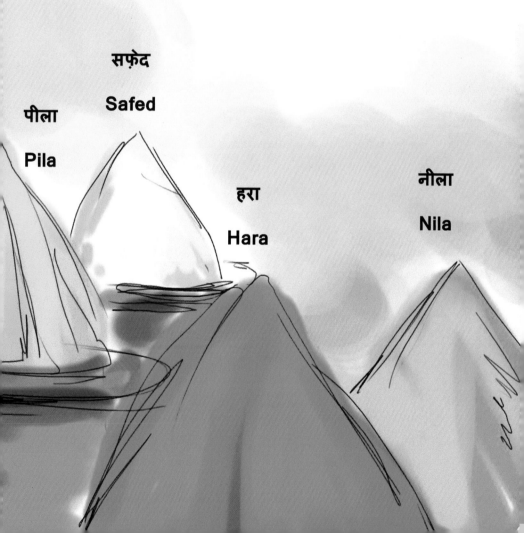

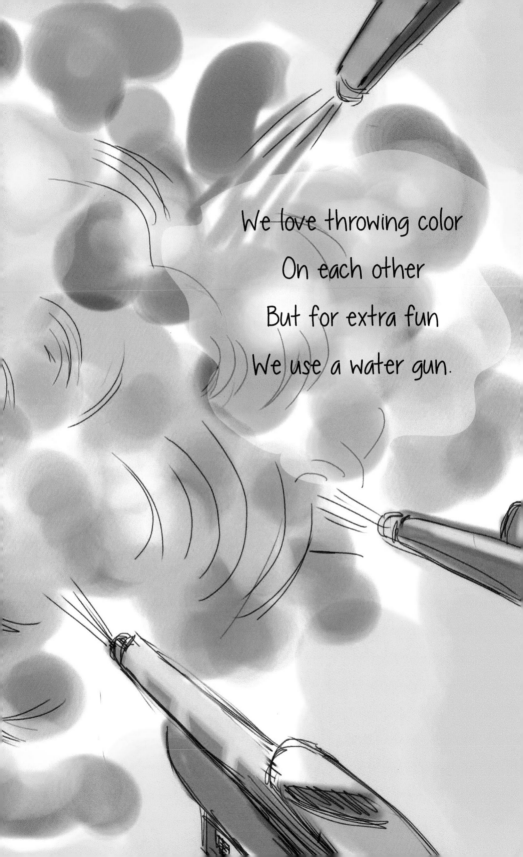

We love throwing color
On each other
But for extra fun
We use a water gun.

On a dare
I put paint in Sia's hair
she did not care
because Holi Hai!
What a fun day
to play with color this way.

Harris County Public Library, Houston, TX

CPSIA information can be obtained at www.ICGtesting.com
Printed in the USA
LVIW01n2246210916
505699LV00001B/1